Pencil Drawing

WITH MIKE BUTKUS, MICHELE MALTSEFF,
WILLIAM F. POWELL, AND MIA TAVONATTI

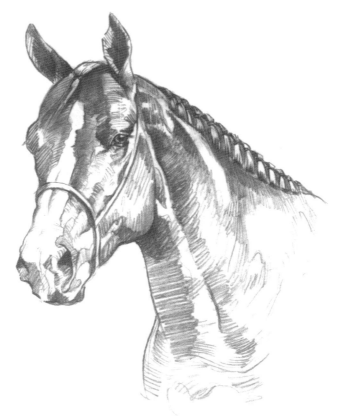

Contents

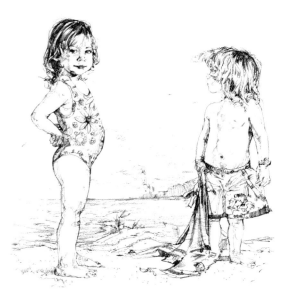

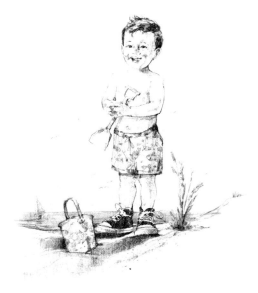

Introduction

The popular art of drawing is ages old, and it is the most important foundation for all the visual arts. It is also a very approachable art, and easy to learn. In fact, you already know how to draw: Anytime you doodle or make a mark with a pencil, you're drawing! All you need beyond that is the knowledge of a few pencil techniques and some simple drawing rules—and the most important rule is to simply draw what you see. The more you practice and the more you train your eye to really see, the better your drawings will become!

This book introduces you to some basic techniques and presents some simple lessons that will help you get started drawing everything from flowers and fruit to animals and landscapes. You'll learn how to break down each subject into a few simple shapes, so you can render anything you choose, no matter how complex. You'll also discover what tools and materials you'll need and the kind of strokes each type of pencil makes. And once you've had fun experimenting with the projects in this book, you'll be ready to set off on your own drawing adventures!

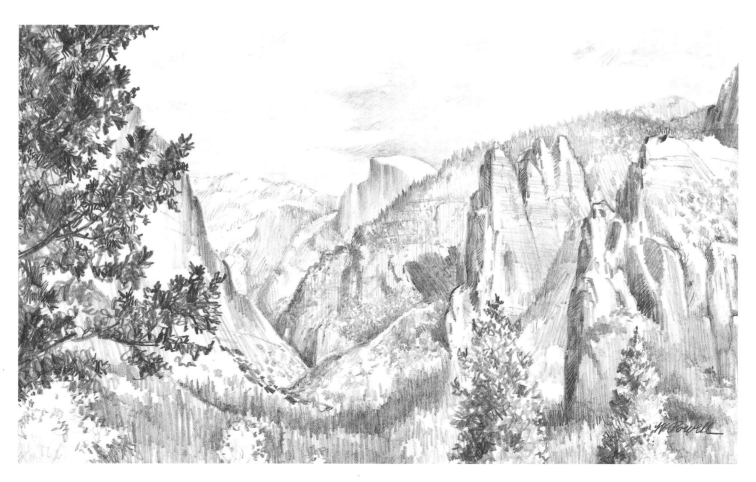

Tools and Materials

Gathering the Basics

You don't need a lot of supplies to start drawing in pencil; you can begin enjoying drawing with just a few pencils, a sharpener, an eraser, and any piece of paper. You can always add more supplies to your cache later, but these basic materials will get you off to a good start.

Pencils

Pencils are labeled with a combination of letters and numbers that indicate the degree of lead softness. Pencils with B leads are softer than ones with H leads, and so they make darker strokes. And a 6B is softer than a 2B, so it makes darker strokes also. An HB is in between, which makes it very versatile and a good beginner's tool. Reeves manufactures a variety of drawing pencils to choose from. Pencils also come in different shapes—flat or round—and can be used with rounded tips or very fine points, depending on the effect you want to create. The chart on page 6 shows samples of drawing tools and the kind of strokes that are achieved with each one. Practice using different points and varying the pressure you put on the pencil.

Sketch Pads

Drawing pads and sketchbooks come in a wide variety of sizes, textures, and bindings. Small pads are particularly handy for making quick sketches when traveling or drawing outdoors. Large pads are useful in the studio when you're planning a large composition (see page 24) or drawing a figure from life. Whether you choose a smooth surface or one with more texture is a matter of personal preference; you may want to experiment with different textures to see which works best for you. If you plan to take the pad with you when traveling or sketching outdoors, you may want one with a spiral binding. This way you can turn the finished pages to the back, which protects them from damage or from being blown by the wind!

Drawing Papers

For finished works of art, you may prefer using single sheets of drawing paper. They are of better quality than the paper in sketch pads, and you don't have to clean up any perforated edges. They are available in a range of surface textures (called "tooth"): smooth grain (plate and hot pressed), medium grain (cold pressed), and rough to very rough. The cold-pressed surface is probably the most versatile. It is of medium texture but not totally smooth, which makes it a good surface for beginners and for a variety of different drawing techniques. You can also purchase colored drawing papers—they provide a middle tone so all you need to draw are the lightest and darkest values (see pages 22–23 for more on value).

Artist's Erasers

A kneaded eraser is very handy; it can be formed into small wedges and points to remove marks in very tiny areas. Vinyl erasers are appropriate for larger areas; they remove pencil marks completely. Both are safe to use on drawing paper; kneaded erasers are soft, and vinyl erasers won't damage the paper surface unless scrubbed too hard.

Blending Stumps

Paper blending stumps are soft paper cylinders with pointed ends. They are used to blend and soften small areas where your finger or a cloth is too large. You can also use the sides of the stumps to quickly blend large areas in your drawing. Once the stumps become dirty, simply rub them on a cloth to clean them, and they're ready to go again.

Utility Knives

Utility knives (also called "craft" knives) are great for cleanly cutting drawing papers and mat board. You can also use them for sharpening pencils, but be careful; the blades are very sharp. Blades come in a variety of shapes and sizes and are easily interchanged.

Warming Up with Pencils

Drawing is, first and foremost, about observation. If you can look at what you're drawing and really see what's in front of you, you're halfway there already—the rest is technique and practice. So let's warm up by sketching a few basic three-dimensional forms—spheres, cylinders, cones, and cubes. Gather some objects from around your home to use as references, or study the examples below. And by the way, feel free to put a translucent piece of paper over these drawings and trace them. It's not cheating—it's good practice.

Starting Out Loosely

Begin by holding the pencil loosely in the underhand position (see the box below). Then, using your whole arm, not just your wrist, make a series of loose circular strokes, just to get the feel of the pencil and to warm up your arm. Keep your grip relaxed so your hand does not get tired or cramped, and make your lines bold and smooth. Now start doodling—scribble a bunch of loose shapes without worrying about drawing perfect lines. You can always refine them later.

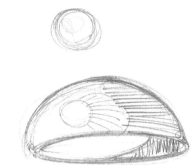
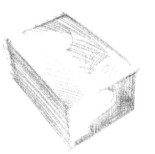

ROUGHING IN Lightly sketch the basic shapes of a variety of objects, roughly indicating the shaded areas (see page 6 for more on shading). Also look at the shape of the shadow the object throws, and use your darkest shading here. Experiment by using different types of pencils (H, HB, 2B), changing the pressure on your pencil, and see what different lines you can create.

Basic Hand Positions

The way you hold your pencil will depend on the type of drawing you want to do. Fine detail work is best done with a sharp pencil held as though you were writing. Large, loose sketches are more easily accomplished holding the pencil underhand. Use the side of your pencil held at an angle against the paper for broad, soft lines or for shading large areas. As you draw, change pencil positions often and notice the difference this makes in the quality of your lines.

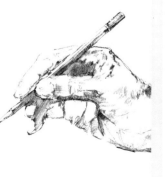

Handwriting position **Underhand position** **Pencil on side of lead**

Pencil Techniques

Shading Techniques

Shading enables you to transform mere lines and shapes into three-dimensional objects. *Shape* refers to the actual outline of an object, and *form* refers to its three-dimensional appearance. Some simple examples of shading techniques are shown below; for more, see "Beginning with Basic Shapes" on pages 10–11 and "Still Lifes" on pages 22–23.

As you can see, pencils can be used with sharp, round, and blunt points, and several techniques can be combined on one surface. The paper stump helps smear the lead, making a softer blend. Experiment and see what kinds of textures you can create on your own.

This is an oval *shape*.

This has a three-dimensional, ball-like *form*.

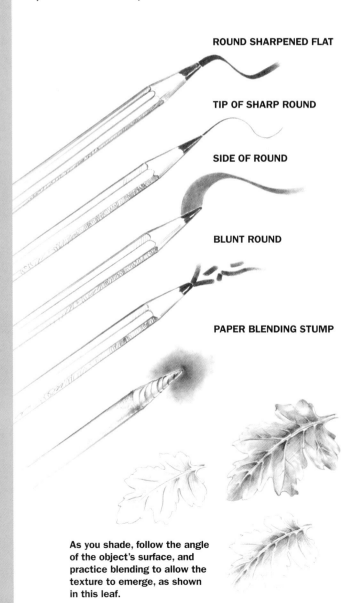

ROUND SHARPENED FLAT

TIP OF SHARP ROUND

SIDE OF ROUND

BLUNT ROUND

PAPER BLENDING STUMP

As you shade, follow the angle of the object's surface, and practice blending to allow the texture to emerge, as shown in this leaf.

LEFT: Use a sharp-pointed HB to draw this line pattern. *RIGHT:* Shade a light background with a round-pointed HB. Then use a sharp-pointed one to draw the darker, short lines over the background.

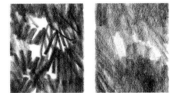

LEFT: Create blends and lines like these with a blunt round 2B pencil. *RIGHT:* Use the same technique as in the example at left; then blend softly with your finger or with a paper blending stump.

LEFT: Draw groups of randomly patterned lines with a round HB. *RIGHT:* Use the side of an HB to shade the background, blend with a paper stump, and then add patterned lines over the background.

LEFT AND RIGHT: Shade the background lightly using the side of a 2B pencil. Then apply a little more pressure for the darker patterns, varying the angle of the pencil to create the pattern.

Make intricate patterns like the ones above using the side, the rounded tip, and the sharpened point of an HB pencil. Shade the backgrounds first, and then draw the patterns on top. Apply more pressure to create the darker areas.

Gradual blends like these can be made using the side of a 2B pencil. Start lightly and increase the pressure as you work from left to right. Shade in one direction to make the vertical finish on the left. Blend with angles for the smoother finish on the right.

Surfaces and Textures

There are many ways to render the surfaces and textures of objects. The examples here illustrate some common techniques. Practice rendering these examples yourself before trying an entire drawing, and refer back to these techniques when necessary as you work.

Observe the different textures and effects produced by using different pencil points and stroke directions. Some results are created by drawing sideways and others by pushing and pulling with your pencil. For more examples of different textures, see "Textures" on pages 24–25.

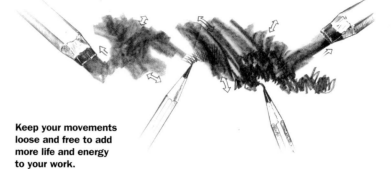

Keep your movements loose and free to add more life and energy to your work.

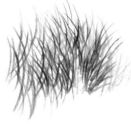

Use long, overlapping strokes in varying directions to indicate tall grasses.

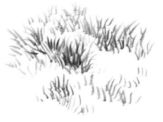

Use *hatched* (angled) lines to create shorter grass. Leave some clear areas for ground.

To create the appearance of wood grain, begin by lightly indicating the pattern you see on a piece of wood, following the direction of the grain.

Start shading by using simple, angled lines. Darken some areas more than others by applying more pressure, always following the grain.

Place short strokes closer together for smooth surfaces, like an eggshell. Use long, curved strokes placed farther apart for a rough ball of string or yarn.

For bricks, stones, or other intricate patterns, first draw the outline of the shapes to establish the overall pattern, and then shade all the surfaces.

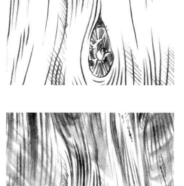

In the final step, use the side of the pencil to create the uneven, grooved texture shown here.

Starting with Sketches

Sketching is a wonderful method of quickly capturing an impression of a subject. Depending on the pencil lead and technique used, you can swiftly record a variety of shapes, textures, moods, and actions. For example, dark, bold strokes can indicate strength and solidity; lighter, more feathered strokes can convey a sense of delicacy; and long, sweeping strokes can suggest movement. You can make careful sketches to use as reference for more polished drawings, but loose sketches are also a valuable method of practice and expression, as the examples on these pages show. Practice different strokes and sketching styles; with each new exercise, your hand will become quicker and more skilled.

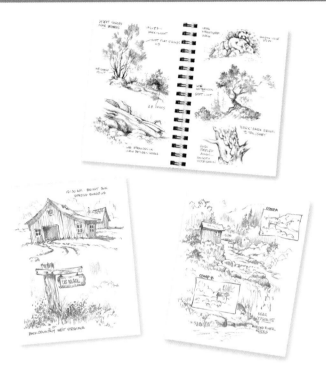

USING CIRCULAR STROKES
Loose, circular strokes are great for quickly recording simple subjects or for working out a still life arrangement, as shown in this example. Just draw the basic shapes of the objects and indicate the *cast shadows* (the shadows cast by the objects); don't worry about rendering details at this point. Notice how much looser these lines are compared to the examples from the sketchbook shown at right.

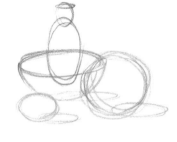

RECORDING YOUR IMPRESSIONS Here are a few pages out of a sketchbook. Along with sketching interesting 0things you see, make notes about the mood, colors, light, time of day—anything that might be helpful when you refer back to them. Carry a pad and pencil with you at all times; you never know when you will come across an interesting subject you'd like to record in a quick sketch!

SCRIBBLING Free, scribbled lines can also be used to capture the general shapes of objects such as clouds, treetops, or rocks. Use a soft B lead pencil with a broad tip to sketch the outlines of the clouds; then roughly scribble in a suggestion of shadows, hardly ever lifting the pencil from the drawing paper. This technique effectively conveys the puffy, airy quality of the clouds.

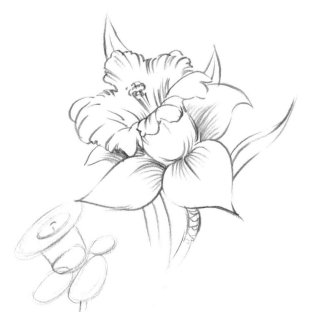

USING WIDE, BOLD STROKES
This method is used for creating rough textures and deep shadows, making it ideal for subjects such as foliage and hair and fur textures. For this example, use the side of a 2B pencil, varying the pressure on the lead and changing the pencil angle to produce different *values* (lights and darks) and line widths. This creates the realistic form and rough texture of a sturdy shrub.

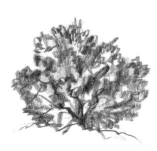

SKETCHING FOR REFERENCE MATERIAL Here is an example of using a rough sketch as a source of reference for a more detailed drawing. First use loose, circular strokes to record an impression of the flower's general shape (left), keeping the lines light and soft to reflect the delicate nature of the subject. Then use the sketch as a guide for the more fully rendered flower (right).

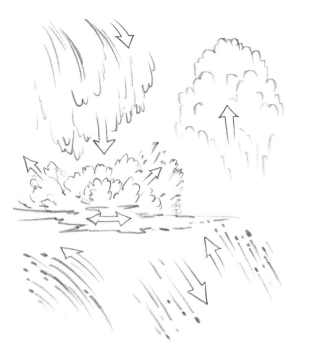

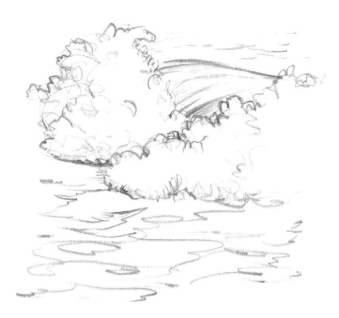

CONVEYING MOVEMENT To show movement in a drawing, you need to fool the viewer's eye into believing that the object is moving up, down, or sideways. The arrows shown above indicate the direction of movement, but the pencil strokes are actually made in the opposite direction. Press down at the beginning of each stroke to get a strong line, lifting the pencil at the end to taper it off. Note how these lines convey the direction of the water and the rising movement of smoke.

RENDERING WAVE ACTION Try quickly sketching a wave, using long, flowing strokes to indicate the arcing movement of the crest and making tightly scribbled lines for the more random motions of the water as it breaks and foams. As in the examples at left, the strokes taper off in the direction opposite the movement of the wave. Also sketch in a few meandering lines in the foreground to depict the slower movement of the pooled water as it flows and recedes.

Focusing on the Negative Space

Sometimes it's easier to draw the area around an object rather than actually drawing the object itself. The area around and between objects is called the "negative space." (The actual objects are the "positive space.") If an object appears to be too complex or if you are having trouble "seeing" it, try focusing on the negative space around it instead. At first it will take some effort, but if you squint your eyes, you'll be able to blur the details so you see only the negative and positive spaces as shapes. You'll find that when you draw the negative shapes around an object, you're also creating the outside edges of the object at the same time. The examples below are simple demonstrations of how to draw negative space to create a fence or stand of trees. Select some objects in your home and place them in a group, or go outside and look at a clump of trees or a group of buildings. Then try sketching the negative space, and you'll find that the objects will seem to emerge almost magically from the shadows!

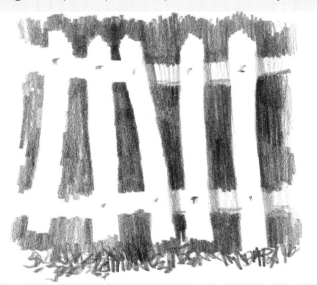

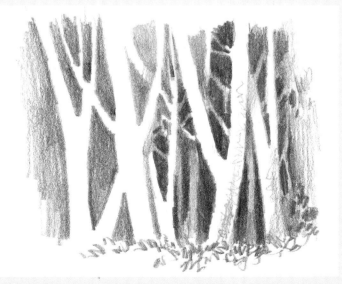

FILLING IN Create the white picket fence by filling in the negative spaces around the individual slats. Don't draw the slats themselves—draw the shapes surrounding them, and then fill in those negative shapes with the side of a soft lead pencil. Once you have established the shape of the fence, refine the sketch a bit by adding some light shading on the railings.

SILHOUETTING This stand of trees is a little more complicated than the fence, but sketching the negative spaces simplifies it immensely. Use the same technique used on the fence, filling in the shapes with the side of the pencil. Here the negative shapes between the tree trunks and among the branches are varied and irregular, which adds a great deal of interest to the drawing.

Beginning with Basic Shapes

Anyone can learn to draw by simply breaking down the subject into a few basic shapes. Just about every object you can think of to draw can be simplified into shapes such as circles, rectangles, squares, and triangles. If you draw an outline around the basic shapes of your subject, you've drawn its shape. But, as mentioned before (see page 6), your subject also has depth and dimension, or form, and if you transform your shapes into forms, you can make your subject appear three-dimensional even before you add shading. The corresponding forms of the basic shapes are spheres, cylinders, cubes, and cones, shown in the example at right. For example, a ball and a grapefruit are spheres, a jar and a tree trunk are cylinders, a box and a building are cubes, and a pine tree and a funnel are cones. That's all there is to the first step of every drawing: sketching the shapes and developing the forms. After that, it's just a matter of connecting and refining the lines and adding details.

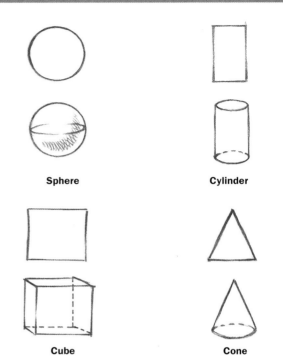

Sphere

Cylinder

Cube

Cone

CREATING FORMS Here are the four basic shapes and simple versions of their respective forms. Think of the shapes as flat frontal views of the forms. When tipped, they resemble the forms below. Then use ellipses to show the backs of the circle, cylinder, and cone, and draw a cube by connecting two squares with parallel lines.

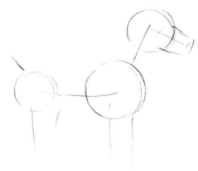

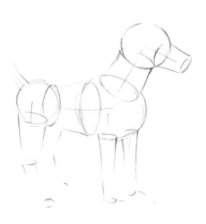

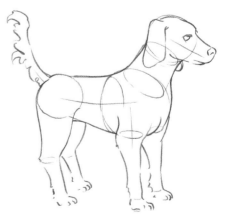

COMBINING SHAPES Here are two simple examples of beginning a drawing with basic shapes: a chick and a dog. Start by drawing each line of action, or *action line,* to establish the angle and posture or line of movement of each animal (see also "Describing the Action Line" on page 31). Then build up the shapes of the dog and the chick with simple ovals, circles, rectangles, and triangles.

BUILDING FORM Once you have established the basic shapes of the different parts of both the chick and the dog, it is easy to begin building up the forms with various sizes and shapes of cylinders, spheres, and cones for the different body parts. Notice that both subjects are now beginning to show some depth and dimension, even though the lines aren't yet refined and there isn't any shading at all.

DRAWING THROUGH The term *drawing through* means drawing the complete forms, including the lines that will be hidden from sight. In this step, you can see indications of the back side of the dog and chick. Even though you won't see that side in the finished drawing, drawing it makes sure the subject will appear three-dimensional. To finish, simply refine the outlines and add a little texture.

Seeing the Shapes and Forms

Now train your eye and hand by practicing drawing objects around you. Set up a simple still life—like the apple, book, and jug arrangement below—and look for the basic shapes in each object. Try drawing from photographs, or copy the drawings on this page. Once you've reduced a complex subject to basic shapes, you can draw anything!

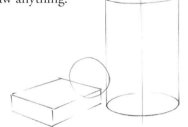

Begin with squares and a circle, and then add ellipses to the jug and lines for the sides of the book. Draw the whole apple, not just the part that will be visible. (This is another example of drawing through.)

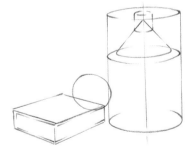

Next add an ellipse for the body of the jug, a cone for the neck, and a cylinder for the spout. Also pencil in a few lines on the sides of the book, parallel to the top and bottom, to begin developing its form.

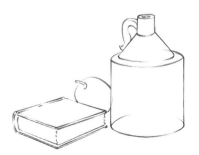

Finally refine the outlines of the jug and the apple, and then round the book spine and the corners of the pages. Once you're happy with the drawing, erase all the initial guidelines, and your line drawing is complete.

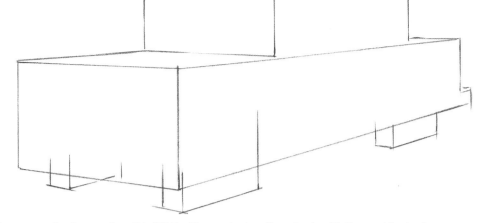

Even a complex form such as this '51 Ford is easy to draw if you begin with the most basic shapes you see. At this stage, ignore all the details and draw only squares and cubes. These are only guidelines, which you'll erase when my drawing is finished, so draw lightly and don't worry about making perfectly clean corners.

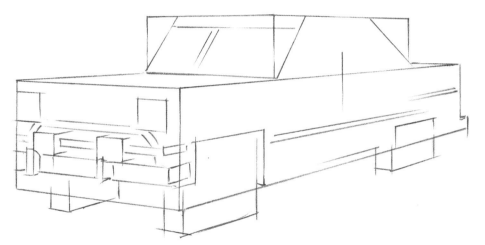

Using those basic shapes as a guide, start adding more squares and rectangles for the headlights, bumper, and grill. Then begin to develop the form of the windshield with angled lines, and sketch in a few straight lines to place the door handle and the side detail.

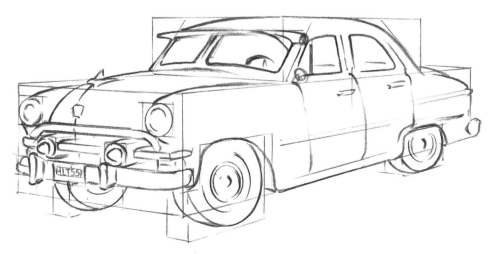

Once you have all the major shapes and forms established, begin rounding the lines and refining the details to conform to the car's design. The guidelines are still in place here, but as a final step, clean up the drawing by erasing the extraneous lines.

Lesson One: Fruit

Peach

Study your subject closely, and lightly sketch the simple shapes; the details will be added later. For the peach and the slice, draw the general shapes in Step 1. In Step 2, place guidelines for the texture of the peach pit and the cavity on the slice. Begin shading the outside of the peach with long, smooth strokes to bring out its curved surface in Step 3. Use a sharp 2B pencil to create the dark grooves on the pit and the irregular texture on the slice. Finish with lines radiating outward from the pit and the top of the slice.

Cherry

Lightly block in the cherry shape and the stem in Step 1, using a combination of short sketch lines. In Step 2, smooth the sketch lines into curves, and add the indentation for the stem. Then begin light shading in Step 3. Continue shading until the cherry appears smooth. Use the tip of a kneaded eraser to remove any smears in the highlights. Then fill in the darker areas using overlapping strokes, changing stroke direction slightly to give the illusion of three-dimensional form to the shiny surface.

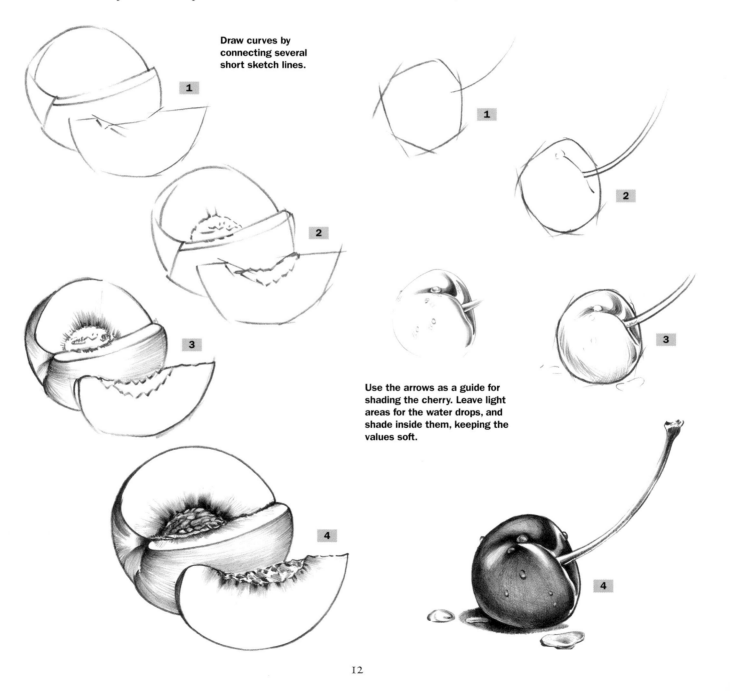

Draw curves by connecting several short sketch lines.

Use the arrows as a guide for shading the cherry. Leave light areas for the water drops, and shade inside them, keeping the values soft.

Strawberries

These strawberries were drawn on plate-finish bristol board (a type of stiff illustration board) using only an HB pencil. Block in the berry's overall shape in Steps 1 and 2 to the right. Then lightly shade the middle and bottom in Step 3, and scatter a seed pattern over the berry's surface in Step 4. Once the seeds are in, shade around them. It's important to shade properly around the seeds, creating small circular areas that contain both light and dark values. Also develop highlights and shadows on the overall berry to present a realistic, uneven surface.

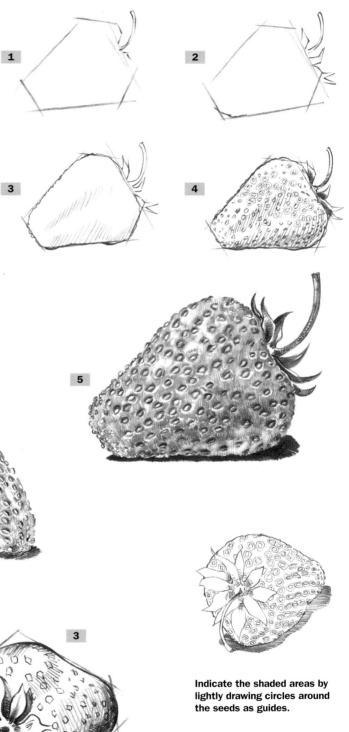

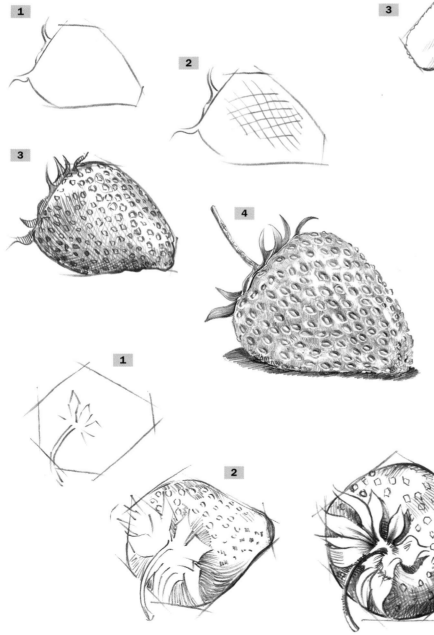

Indicate the shaded areas by lightly drawing circles around the seeds as guides.

Lesson Two: Flowers

Poppy

The California poppy grows in a variety of colors, from deep orange to pale yellow. The blossoms are paperlike and delicate, and the flower spreads to about 2 inches wide. Use the diagram below to draw the whole plant, and follow the steps to the right for the individual flower.

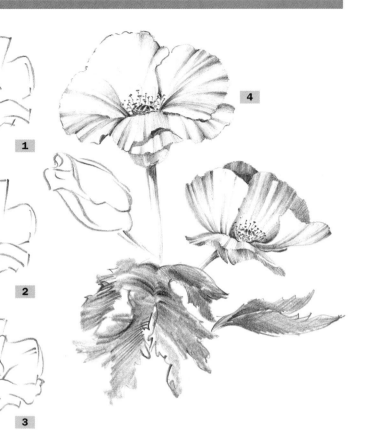

Pansy

Pansies grow in many color combinations. Sometimes these combinations resemble faces, almost seeming to have expressions. When drawing the pansy, use the steps to overlap the petals so each one slightly covers another near the edges. Notice that the dark shading near the center gives the illusion of the flower having two colors, as well as three-dimensional form.

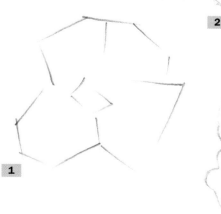

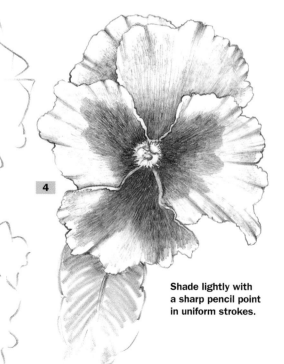

Shade lightly with a sharp pencil point in uniform strokes.

14

Floribunda Rose

Floribunda roses grow in groups of blossoms. The arrangement of the petals in these roses is involved; but by studying it closely, you'll see an overlapping, swirling pattern. Use a blunt-pointed HB pencil lightly on plate-finish bristol board. Outline the overall area of the rose mass in Step 1. Once this is done, draw the swirling petal design as shown in Steps 2 and 3. Begin fitting the center petals into place in Step 4. Then use the side of an HB to shade as in Step 5, being careful not to cover the water drops; they should be shaded separately. The downward shading lines follow the angle of the leaf surface, and the pattern suggests veining. Use a kneaded eraser to pull out highlights.

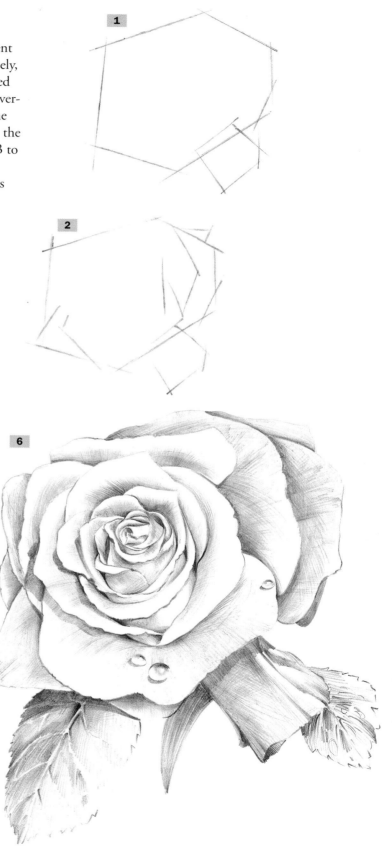

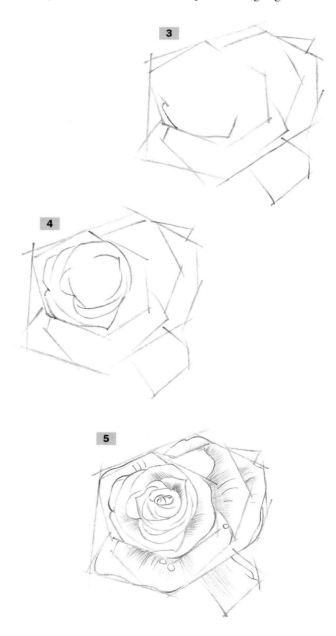

Lesson Three: Dogs

Great Dane

Great Danes have a regal stature and a chiseled muzzle. In Steps 1 and 2, use an HB pencil to block in the dog's large head. Notice the droopy lips and eyelids, which give the Great Dane a pleading expression. Refine the shapes, and lightly shade with a 2B pencil to bring out the form and contours of the head in Step 3. The minimal shading will give the coat a smooth appearance. Add darker values within the center of the ear to create the curvature of the ears, "carving out" the area through shading, as shown in the final drawing. To enhance the shine of the nose, shade it evenly, and erase out a large highlight.

The erect ears can be developed from simple triangle shapes.

Use a kneaded eraser to pull out the highlight on the nose.

Old English Sheepdog

The most distinctive feature of the Old English sheepdog is its long fluffy coat, which sometimes covers the dog's eyes and hides the ears. This particular rendering doesn't require many fine details, but the coat does need some attention. Lay down a basic outline in Step 1, adding some suggestions of hair in Step 2. Keep your lines loose and free. As you begin to develop the coat, notice how the nose, tongue, and eyes differ in texture; they are quite smooth in contrast to the hair. Use a blunt-pointed pencil to lay in the coat, adding more shading layers to the back end of the body to indicate the darker color. Enhance the texture by molding a kneaded eraser into a sharp edge and erasing with the edge in the direction of the strokes. This brings out highlights and creates shadows between the hairs.

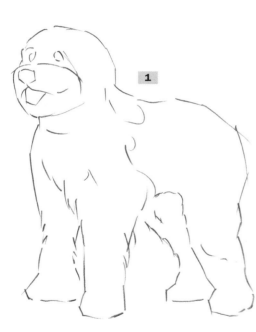

2

1

3

Keep the values within this area darker to denote the change in fur color.

Lesson Four: Horses and Ponies

Arabian

The Arabian is a high-spirited horse with a flamboyant tail carriage and a distinctive dished profile. Try to capture the Arabian's slender physique and high spirit in your drawing. Block in the body with an HB pencil, placing the oval for the body at a slight angle to indicate the angle of the body. Take care when blocking in the head to stress the concave nose, large nostrils, and small muzzle. As you start shading in Steps 2 and 3, keep the lines for the tail and mane loose and free, and accent the graceful arch of the neck. Refine your shading with a soft lead pencil and a paper stump, leaving large areas of white for the highlights. These highlights show the shine on the horse's coat and indicate the direction of the light source.

Be sure to emphasize this horse's narrow chest and face to convey its delicate build.

From this angle, the line of the spine is visible. Add subtle shading here and along the withers to give your drawing a three-dimensional quality.

Shetland Pony

The Shetland is a hardy animal originally from the Shetland Islands of Northern Britain. This pony exhibits the characteristic small head, thick neck, and stocky build of the breed. As you block in the pony's body, carefully observe its proportions; the length of its body is about two and a half times the length of its head. In Step 1, start with large circles and ovals to capture the pony's solid build. Use hatched strokes to start indicating the middle values as shown in Step 2, using a paper stump to blend the darkest areas in Step 3.

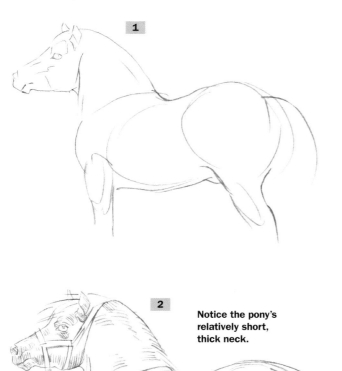

Notice the pony's relatively short, thick neck.

Use the side of the lead and a paper stump for light, wispy strokes to finish off this light-colored pony.

Lesson Five: Cats and Kittens

This kitten's somewhat precarious position allows you to study its proportions (see page 22). Note that kittens have round, barrel-shaped bodies in comparison to the long, lanky bodies of adult cats. Sketch in the branch in Step 1 so that it is at a slight angle. Then block in the kitten's body around the branch. Be careful not to make the body too elongated; show it curving around and under the branch. Use a sharp HB pencil to lightly indicate the face, belly, legs, and tail. In Step 2, use a 6B pencil to flesh out the features and develop the fur and the branch. Use dark, uniform strokes for the underside of the branch and the kitten's footpads. Vary the values to create a striped effect in the fur. Next use an HB pencil for the whiskers over the eyes and the fine lines around the nose, eyes, and mouth. Continue creating the texture of the kitten's coat by making deliberate strokes of different lengths following the directions of fur growth.

Use the sharp point of an HB pencil to show the claws protracting from the rear toes.

FORESHORTENING Unless your subject is being viewed in profile, there will always be a part that is closer to you. The drawing technique called "foreshortening" allows you to create the illusion of depth by shortening the part of an object that is coming toward you. In this drawing of a tiger, notice the foreshortening of the cat's front legs and body; if he were standing, there would be much more distance between his paws and his chest, and his head certainly would not be sitting in the middle of his body! By distorting the proportions this way, you can convey a sense of depth and perspective.

Drawing Fur and Hair

SMOOTH COAT Shade the undercoat with the side of a blunt **2B**, and pick out random hairs with a sharp **HB** pencil.

ROUGH COAT Using the side of your pencil, shade in several directions using different strokes and various pressures.

LONG HAIR Make wavy strokes in the direction the hair grows, lifting the pencil at the end of each stroke.

SHORT HAIR Use a blunt **HB** to make short, overlapping strokes, lifting the pencil at the end to taper the tips.

Lesson Six: Still Lifes

A *still life* is an arrangement of inanimate objects, and it can be as simple or as elaborate as you choose. Still lifes make wonderful drawing subjects because you have complete control over the lighting and the placement of the objects, and the objects won't move while you're drawing them! Try to make a pleasing setup, or composition, by establishing a center of interest and a line of direction that carries the viewer's eye into and around the picture—but don't place the focal point right in the center of the picture field. Place it higher or lower or off to one side to create more visual interest. Also create a sense of depth by overlapping objects, varying the values, and placing elements on different planes. Try a number of different arrangements and viewpoints until you find a composition that pleases you. Then draw it!

ARRANGING THE ELEMENTS This setup includes a variety of objects of differing shapes and sizes, overlapping each other and placed on a white cloth. Notice that the objects also represent each end of the value scale—from the white candle to the black jewelry box. These extreme contrasts in value (the strong lights and darks) make a more interesting drawing than one with only mid-range tones.

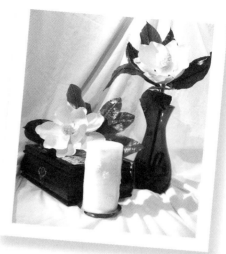

STEP ONE First use the point of an HB pencil to lightly block in the basic shapes; then refine the lines as needed. Pay special attention to the size relationships *(proportions)* among all the objects and the elements within each object. Make sure all the proportions are accurate before going on to Step 2.

STEP TWO Next begin shading using the side and the rounded point of an HB pencil. Use hatching strokes for the light- and mid-values, pressing a little harder to deepen the darker areas and leaving pure white for the lightest highlights. At this stage, be careful not to go too dark in any one area.

Exploring Drapery Shading Techniques

When drawing a still life, you'll probably want to incorporate some type of drapery to enhance the arrangement, as in the still life above. Draw the folds as you would any object: Squint your eyes to help you see the different values more easily, and then simply draw what you see. The examples below utilize a variety of different drawing media (pencil, charcoal, and Conté crayon) to show what effects you can achieve.

PENCIL POINT The point of an HB pencil creates thin lines, so use overlapping hatched strokes for the dark values in the folds.

PENCIL SIDE Make flat, loose strokes with the side of the pencil. Each stroke covers a lot of area, creating a less-refined look.

CHARCOAL Use charcoal pencils or sticks to block in the different values. Then blend them with your finger and a paper stump.

CONTÉ For a soft look, block in with a black Conté crayon (a very dense, chalklike stick), layer with white, and then blend slightly.

STEP THREE After creating the base of light- and mid-values, gradually develop the darkest values, using an HB pencil. Notice that the dark objects aren't all dark and the white objects aren't all white. Each element has a range of values that gives it form. Squint your eyes often to help you see the different values, and if one area jumps out too much, either tone it down or bring up the areas around it to match its value. In the last phases of the drawing, add a few dark accent areas, such as on the corners of the jewelry box and in the deep shadows on the leaves. These accents help make the drawing come alive, and the subtle contrasts make it "pop."

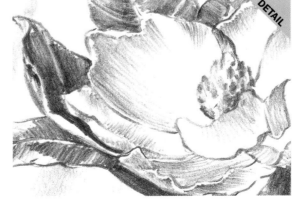

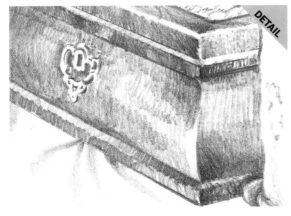

SHADING HARD EDGES On this box, the hard edges are sharp and clearly defined. The pure white highlights on the corner and the lid are where the light strikes most directly.

SHADING SOFTER SURFACES Unlike the box, the flowers have soft edges. The highlighted petal edges are defined by the dark leaves behind them, not by a hard, drawn line.

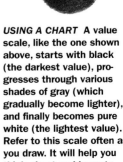

USING A CHART A value scale, like the one shown above, starts with black (the darkest value), progresses through various shades of gray (which gradually become lighter), and finally becomes pure white (the lightest value). Refer to this scale often as you draw. It will help you think about and learn to really see the variations of values in different objects.

Lesson Seven: Textures

Textures are great fun to draw, and because each type of texture requires a different pencil technique, they add a tremendous amount of interest to a drawing. Test your observation skills by studying the textures of different subjects: Are they rough or smooth? Hard or soft? Dark or light? Then try to determine how to convey these qualities in your drawings. For instance, you would draw the texture of a plastered wall differently than you would a brick wall, a wooden wall, or one with peeling paint. And a piece of torn or broken bread has a different texture than a piece that's been neatly sliced. Some surfaces, such as rocks or tree trunks, require a combination of techniques—smooth, blended shading plus a variety of pencil strokes.

One of the best ways to learn how to create different textures is to draw a still life of objects you have at home. Gather items with a variety of different textures, and arrange them in a dynamic composition, like this example with subjects of wood, glass, silver, fabric, liquid, and china. As you follow the steps on page 25, refer to the detailed enlargements above and at right to better see the highlights and the individual pencil strokes.

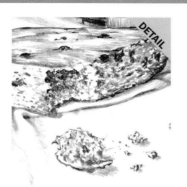

CRUMBLY SCONE Make long, straight strokes with an HB pencil for the smooth portion of the scone, and draw short, hatched strokes of different values and in different directions for the rough edge and the broken portion. For the darker, more solid masses of currants within the scone, use a 2B pencil.

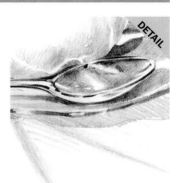

GLASS The best way to indicate the texture or surface of clear glass is to not draw it all—only suggest selected light and dark portions. Use the point and side of an HB pencil for this smooth surface, and vary the values slightly. Notice that the glass also distorts the elliptical surface of the liquid at the left edge of the glass.

SILVER The carefully placed highlights are the most important part of creating the illusion of metal. Notice that the shiny spoon absorbs dark areas and reflects light onto the side of the coffee cup. Use an HB pencil for the mid-tone areas, and smooth them with a blending stump. Then use a 2B pencil to build up the darks.

BASKET To mimic the texture of the basket, use a sharp HB pencil and make vertical strokes for the vertical weave and horizontal strokes for the horizontal weave. Start the strokes at the end of a segment and work toward the middle, pressing firmly at the beginning of each stroke and lifting the pencil at the end.

FABRIC Use a series of short, directional strokes with the blunt point of an HB pencil to make the small, dense weave of the cloth. Use the same strokes in the cast shadow, but make them darker and place them closer together. For the flower pattern, vary the pressure and the density of your strokes to duplicate the design.

LIQUID The coffee is dark, but its surface reflects the light from the side of the cup. Notice that there are several areas of value changes within the dark coffee as well. After establishing the darks in the coffee and the middle and light values in the cup, use a kneaded eraser to pull out highlights on the coffee surface.

THUMBNAIL I worked out the composition in a small "thumbnail" sketch on practice paper before committing it to drawing paper, to check that it "reads" well in two dimensions.

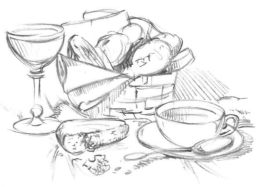

1

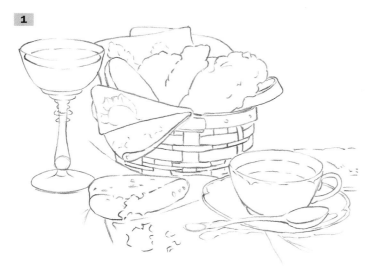

2

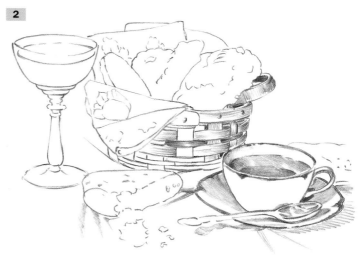

STEP ONE With the point of an HB pencil, block in the general shapes. Then draw the outlines of each element in the composition with very light lines. Take your time on this step, frequently checking your drawing against the arrangement to make sure you have all the proportions right. Draw only a few lines for the folds in the cloth, just for placement; you will develop those forms later with shading.

STEP TWO When you are satisfied with the basic outlined shapes, begin building up their forms with various techniques (see details on page 24). Start with an HB pencil for the light values, and then switch to a 2B and a 4B for the darkest accents. Rather than lay in and build up the values for the whole composition at once, work on one area at a time. That will keep you from being confused by all the details of the entire scene.

3

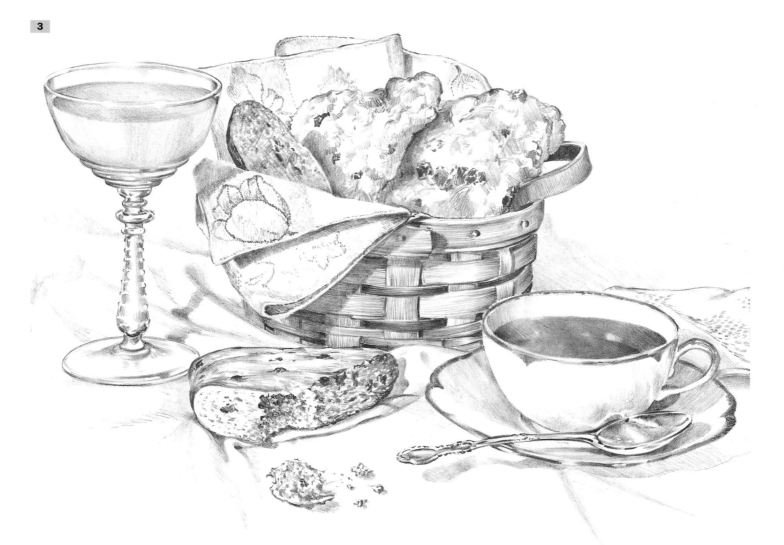

STEP THREE After shading all the objects, finish by pulling out highlights with a kneaded eraser and darkening accents with sharply pointed 2B and 4B pencils.

Lesson Eight: Landscapes

Landscapes are not only fascinating subjects to draw, they are also everywhere around you—in your backyard, in your local park, or in photos you take on vacation. When you travel—even around town—make sketches or take photos of interesting landscapes you see. You can also use books and magazines as reference materials when drawing at home in your studio. Or take your materials outdoors and draw from life. But whether you draw from a photo reference or on location, keep in mind that every landscape should have a well-defined foreground (the area closest to the viewer), middle ground, and background (the area farthest in the distance). As with still lifes, place your focal point off-center, and create a sense of depth by overlapping elements and making them smaller in size as they recede into the distance. Also remember that outdoor scenes are affected by the atmosphere; dust and water particles in the air block out some light, making distant objects appear bluer and hazier. Then begin as with any subject, by breaking down the objects into simple shapes and building up their forms.

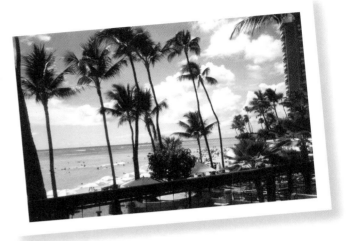

USING PHOTOS FOR REFERENCE Photos don't have to be perfect to be helpful, and you don't have to reproduce them faithfully in your drawings. Even from this overcrowded photo of Waikiki Beach taken from a hotel terrace, you can still glean information about palm trees and cloud formations to be used in the final drawing.

1

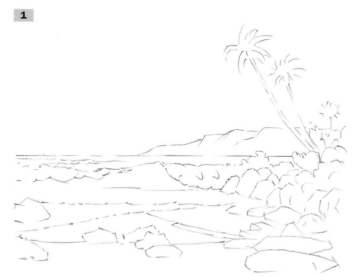

STEP ONE For this sunset scene, lightly block in the outlines of all of the elements with the sharp point of an HB pencil. Notice that the horizon line is slightly below center, not in the middle of the paper.

2

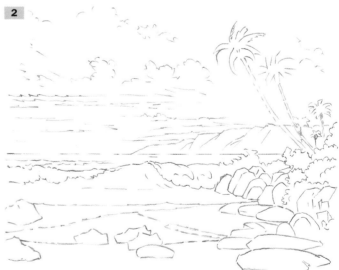

STEP TWO As you develop the contours of each object, keep all the guidelines light, especially in the sky. Just as you do with a still life, check that all elements are in correct proportion before you begin shading.

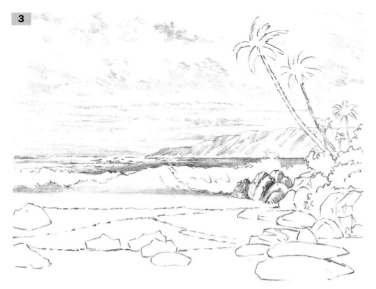

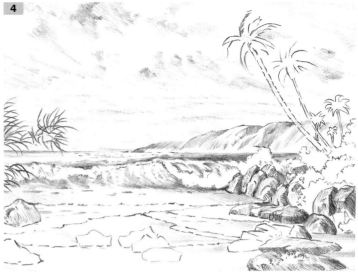

STEP THREE Using the side of an HB lead, build up the values and shapes of clouds in the sky, making sure most of your strokes follow the same angle. Then begin shading the water.

STEP FOUR Next continue adding details and developing depth with shading. Notice how my pencil strokes follow the surface of the water and the shapes of the rocks.

STEP FIVE Develop the shading values and textures using the point and sides of an HB and the point of a 2B. Don't overwork the background; you want to keep it light to better suggest distance.

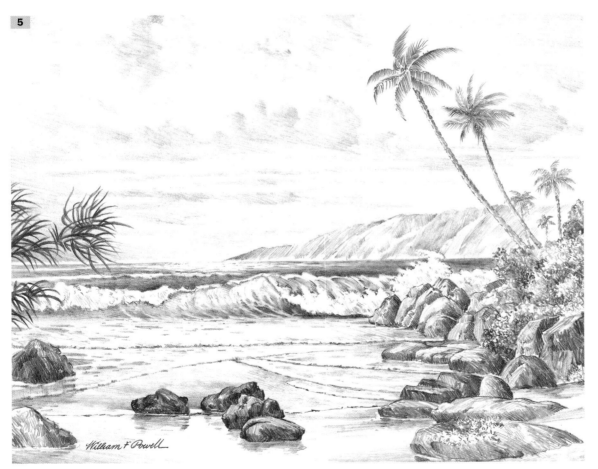

Lesson Nine: Portraits

A good starting point for drawing people is the head and face. The shapes are fairly simple, and the proportions are easy to measure. And portrait drawing is also very rewarding. There is great satisfaction in looking at a portrait you've drawn and seeing a true likeness of your subject, especially when the model is someone close to you.

Drawing a Child's Portrait

When drawing a child's portrait, you'll probably want to draw from a photo, since children rarely sit still for very long! Study the features carefully, and try to draw what you truly see, and not what you think an eye or a nose should look like. But don't be discouraged if you don't get a perfect likeness right off the bat. Just keep practicing!

Drawing the Adult Head

An adult's head has slightly different proportions than a child's head, but the drawing process is the same: sketch in guidelines to place the features, and start with a sketch of basic shapes. And don't forget the profile view. Adults with interesting features are a lot of fun to draw from the side, where you can clearly see the shape of the brow, the outline of the nose, and the form of the lips.

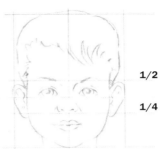

CHILD PROPORTIONS Draw guidelines to divide the head in half horizontally; then divide the lower half into fourths. Use the guidelines to place the eyes, nose, ears, and mouth, as shown.

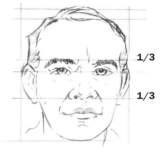

ADULT PROPORTIONS Look for the proportions that make your adult subject unique, like the distance from the top of the head to the eyes and from the nose to the chin. Notice where the mouth falls between the nose and the chin and where the ears align with the eyes and nose.

Common Proportion Flaws

Quite a few things are wrong with these drawings of Gage's head. Compare them to the photo below left, and see if you can spot the errors before reading the captions.

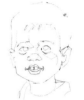

THIN NECK Gage has a slender neck, but not this slender. In the photo, see where his neck appears to touch his face and ear.

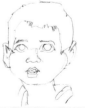

NOT ENOUGH FOREHEAD Children have proportionately larger foreheads than adults do. Drawing the forehead too small adds years to Gage's age.

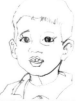

CHEEKS TOO ROUND Children do have round faces, but don't make them look like chipmunks. And don't make the ears pointed.

STARTING WITH A GOOD PHOTO When working from photographs, you may prefer candid, relaxed poses over formal, "shoulders square" portraits. Also try to get a closeup shot of the face so you can really study the features, as in this photo of 2-1/2-year-old Gage.

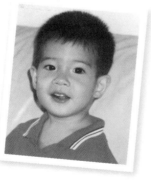

SKETCHING THE GUIDELINES First pencil an oval for the shape of the head, lightly drawing guidelines according to the chart above right, and sketch in the general outlines of the features. Then carefully erase the guidelines.

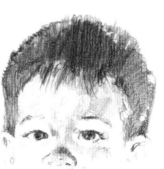

FINISHING THE PORTRAIT With the side of the pencil, lay in the middle values of the shadow areas, increasing the pressure slightly around the eye, nose, and collar. For the darkest shadows and Gage's straight, black hair, use the side of a 2B and overlap your strokes, adding a few fine hairs along the forehead with the sharp-pointed tip of the pencil.

UNNATURAL DETAILS Eyelashes don't stick straight out like spokes on a wheel. And draw the teeth as one shape, not as separate teeth.

Lesson Ten: Children

Children are a joy to watch, and they make charming drawing subjects. If you don't have children of your own to observe, take a sketchpad to the beach or a neighborhood park, and make quick thumbnail sketches of kids at play. Sometimes it actually helps if you don't know your subject personally, because that way you see from a fresh and objective point of view.

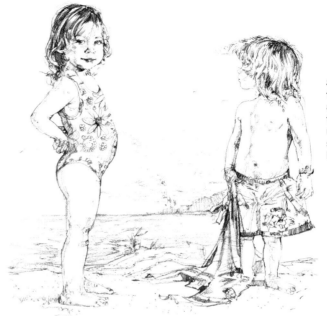

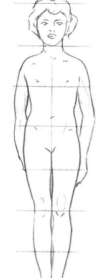

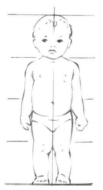

TODDLER PROPORTIONS Toddlers are approximately 4 heads tall, which makes their heads disproportionately large.

CHILD PROPORTIONS By about age 10, children are closer to adult proportions, standing about 7 heads tall.

STAGING To make sure they are the center of attention, place these two youngsters right up in the foreground, so they dwarf the background scenery.

Drawing the Differences

Of course, there's more to drawing children than making sure they're the right number of heads tall. Their facial proportions are different from an adult's (see page 28), and they have pudgier hands and feet with relatively short fingers and toes. They often have slightly protruding stomachs, and their forms in general are soft and round. Keep your pencil lines soft and light when drawing children, and make sure your strokes are loose and fresh.

Making Quick Sketches

Children are more free and flexible in their expressions, gestures, poses, and movements than their more inhibited elders are. To make sure you don't overwork your drawings of children, make speed sketches: watch your subject closely for several minutes, then close your eyes and form a picture of what you just saw. Now open your eyes and draw quickly from memory. This helps keep your drawings uncomplicated—just as children are. Try it; it's a lot of fun!

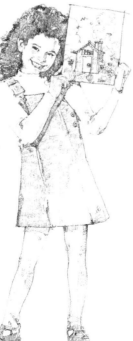

SHOWING HER AGE This pose features the girl's charming expression as she shyly shows off her artwork. She is young, but not a toddler, so her head and legs are more in proportion to her body than they would be in a younger child.

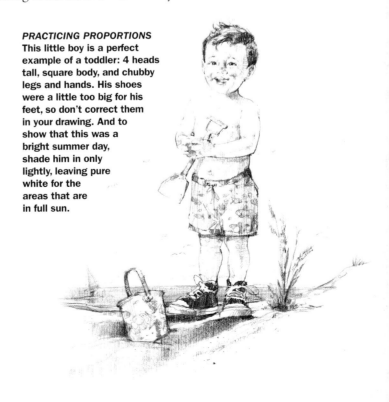

PRACTICING PROPORTIONS This little boy is a perfect example of a toddler: 4 heads tall, square body, and chubby legs and hands. His shoes were a little too big for his feet, so don't correct them in your drawing. And to show that this was a bright summer day, shade him in only lightly, leaving pure white for the areas that are in full sun.

Lesson Eleven: Figures in Action

To draw the human figure from head to toe, it helps to know something about the framework—the skeletal structure—on which it's built. Many art classes have students draw people as skeletons—it is good practice in visualizing how all the parts fit together. You don't have to try that exercise, but do start with simple stick figure sketches of the skull, shoulders, rib cage, and add the arms and legs. Then, once you've got the proportions right, you can flesh out all the forms.

Gesture Drawings

A *gesture drawing* is a quick, rough sketch that illustrates a moment of an action. The idea is just to capture the overall gesture, not to achieve a likeness. Give yourself 10 minutes to draw the entire figure engaged in some sport or full-body activity, working either from life or from a photo. Set a timer and stop when the alarm goes off. Working against the clock teaches you to focus on the essentials and get them down on paper quickly.

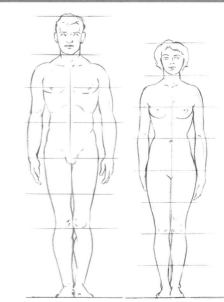

DRAWING THE ADULT FORM The average adult is 7-1/2 heads tall, but artists often draw adults 8 heads tall to add stature. The adult male has wide shoulders and narrower hips, whereas the adult female has narrower shoulders and wide hips. Notice that the midpoint is at the hips, not the waist, and that the fingers reach to mid-thigh. Refer to this chart to help you draw the correct proportions.

DEVELOPING GESTURE DRAWINGS Start with a simple stick figure to catch the motion; then add circles and ovals and flesh out the forms.

Like anything else, the human figure can be broken down into several basic shapes. Practice building a figure with cylinders, boxes, and spheres to help you see the human body in three-dimensional form.

SKETCHING THE ACTION First sketch in diagonal center lines for the arms and legs, adding ovals and circles for the heads and joints. Then rough in the general outlines.

BLOCKING IN SHADOWS To keep the feeling of free movement, don't draw perfectly refined lines and shadows. Instead, focus on making delicate outlines for the dancers, and quickly lay in broad, dark strokes for their clothing.

30

WINDING UP Baseball pitchers balance for a moment on one leg, just before throwing the ball. Drew an S-curve for the action line, to show the way the opposing top and bottom curves keep the player balanced.

One of the most popular subjects for action drawings are sports figures. Although you may enjoy watching the games, it's difficult to make a fully rendered drawing from life; it's easier to work from photos that have stopped the action! Begin by drawing a simple *action line,* which is usually just a curve or diagonal that follows the player's general movement. Then build the rest of the figure around that line, paying careful attention to the way the body maintains its balance. You wouldn't want to have an athlete that appears to be about to fall over!

SWINGING Batters balance on both legs and swing the bat through in a complete semicircular motion. This modified C-curve (an extra turn was added for the foot) catches the full range of the player's movement.

PREPARING THE RETURN Even when a player has paused, there is still a line of action—in this case, two. This woman is crouching and actively holding her racket poised, so draw separate action lines for her body and for her arm.

Conclusion

*N*ow that you have been introduced to the art of pencil drawing, we hope you will continue to explore the possibilities the art form offers. Expand your drawing repertoire by experimenting with other drawing mediums—charcoal, pen and ink, and Conté crayons. Try a variety of different papers, and draw as many different subjects as you can.

Although many artists use pencil drawing as a foundation for drawing and painting in color, it is a beautiful art form on its own, and it will bring you many hours of enjoyment. Take care of your finished pieces; mat and frame them, and protect them from direct sunlight. This way, they will continue to bring pleasure for years to come!

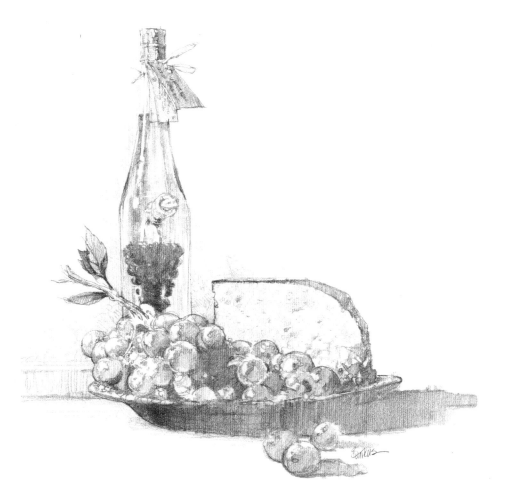